BALTIMORE MODERNISM
PROJECT

**SELECTIONS FROM THE ARCHIVES OF THE
BALTIMORE ARCHITECTURE FOUNDATION**

Introduction: The Baltimore Modernism Project

Hang around with people interested in design and architecture in Baltimore long enough, and eventually the KAGRO building will get a mention. It's easy to spot, on the southwest corner of Maryland and North Avenue, a mini-composition of concrete boxes (architects would say 'volumes') and brick walls ('planes'), stepping down amiably to the streetcorner, inviting passersby inside. Friendly Modernism.

In a recent conversation about KAGRO (originally the Baltimore National Bank, now the Korean-American Grocers Association of Maryland), other small, relatively unknown buildings of the same era and aesthetic started getting namechecked: "What about that one further up Maryland, on 26th?" "What's up with the really big concrete-paneled sucker on Charles and 20th?" "Who designed the WYPR building?" Someone brought up Alex Cochran, usually identified as patient zero for the Modernist infection of post-war Baltimore, someone else mentioned all of the Peterson Brickbauer renderings they'd seen in the back room at the Baltimore Architecture Foundation (some of which are generously on loan for the current show). It was clear that there was the beginning of a thing here.

Conservative Baltimore, so the standard story goes, was late to the fun(ctionalist) Modernist party. Alex Cochran went away to study under Gropius at Harvard, and brought back the Bauhaus to our house.

The Baltimore Modernism Project: 01

The broader history of architecture in the city fleshes out the necessary background to this myth. From the time of Latrobe's Cathedral on, Baltimore has leaned toward the spare clean lines and legible volumes of the Neoclassical and the Georgian. The mass-produced kit-of-parts rationalism of our native rowhouses is an early vernacular example of the populist minimum dwelling imagined by Walter Gropius and Bucky Fuller, among others. With all necessary allowances and caveats for the Eclectic and the Eccentric, Baltimore has always been Modern.

And Modernism in Baltimore never really died, it just got its security and maintenance budget cut (and in some cases, its construction budget woefully, toxically expanded). The physical artifacts left over from the high water mark period of the genre (1945 - 1970, almost exactly coinciding with Baltimore's peak population) are here to stay, however scorned, ignored, or neglected. Say what you like about Modernism's social ambitions (either it tried to do too much, or too little, or should have stayed out of that game entirely, or never was in it in the first place, depending on who you ask), it's hard to deny the power of the *feeling* suggested by the work - that another world was possible. There are plenty of practices in Baltimore's art and design nexus that are quietly (or not so quietly) still busy at work, building even newer possible worlds.

The Baltimore Modernism Project creates a place to put some of these things, not so much to find the

The Baltimore Modernism Project: 01

answers (does anyone know who designed KAGRO, anyway? What year?), but to shake it all around and find out what sticks together, to see the juxtapositions and trace the connections: Georgian Functionalism, Suburban High-density / Highrise, Oneiric Rational Primitive Volumes. One of our favorite descriptors for Dcenter Baltimore itself is that it's a "container and connecter" for an otherwise open-ended and diverse set of issues; so too with the Baltimore Modernism Project. Somewhere in there we can find a link between the recent past and the near future, always both, as the current show suggests, just around the virtual corner.

Fred Scharmen
Midway, 2012

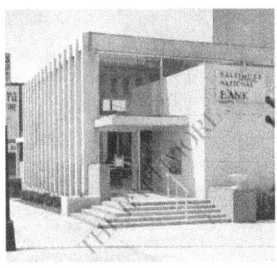 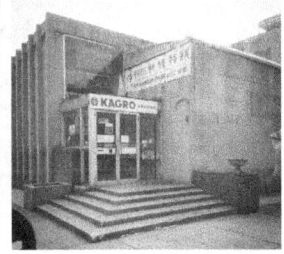

left: Baltimore National Bank, photo credit: Baltimore Sun
right: KAGRO, photo credit: the author

The Baltimore Modernism Project: 01

Pencil, Ink, and Airbrush: Notes on *The Baltimore Modernism Project*

We are used by now to ray-traced shadow-casting, illuminated tablets, and other apparitions which glow and talk and "tweet." Representations of architectural subjects have proliferated in 64-bit "deep color" or, more recently, in stereoscopic, high-definition, high stimulation hues. Today, almost every architectural image appears to radiate with the energy of digital media. Buildings glow [01]. Even the architecture of history has never looked better, whether extruded for Taschen from a Xerox iGen4 EXP printer or stitched together on one's personal smartphone. We all know, of course, that this was not always the case.

Figure 01: Detail: Abu Dhabi Performing Arts Center, Zaha Hadid Architects, Architect & Renderer

Architectural representation was as often dour as attractive, even when the subject might be inspiring and new. Looking at architectural drawings and

photographs was an active exercise in wishful thinking, a practice of seeing past the page or canvas towards something else, newly-imagined. Grey-scale tones might depict any tint in the spectrum, or a bright starburst might refer only ostensibly to what in reality would appear reflective or transparent [02]. Either way, those graphics in no way did glow or talk or tweet. They were flat, they were passive, and so the audience had to be an active partner in the architectural delineator's efforts to envision what was possible.

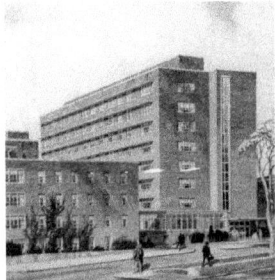

Figure 02: Detail (left): Unknown Medical Building (Exhibit #05), Buckler, Fenhagen, Meyer & Ayers, Architects, J. Floyd Hewell, Renderer; Detail (right) Blue Cross Blue Shield (Exhibit #13), Peterson & Brickbauer, Architects, TESLA, Renderer

The images collected for *The Baltimore Modernism Project* attest to the willing embrace of the possible – possible, that is, a generation ago. These renderings show what would have been, should have been, and (mostly) actually were.

The most celebrated artist represented here, Helmut Jacoby, provided architects worldwide with visions of their work in pristine, nearly abstract environments. Among local examples, the most important of Jacoby's pictures illustrate Charles Center, Baltimore's urban renewal centerpiece. Two renderings show different buildings by the same firm, Peterson & Brickbauer, in collaboration with Emery Roth and Sons. The first, illustrating the **Sun Life Building** [03], testifies to what Baltimore-born Charles Jencks and others have called "Late" Modernism: muscular, vaguely anthropomorphic, and uncompromisingly systematic.

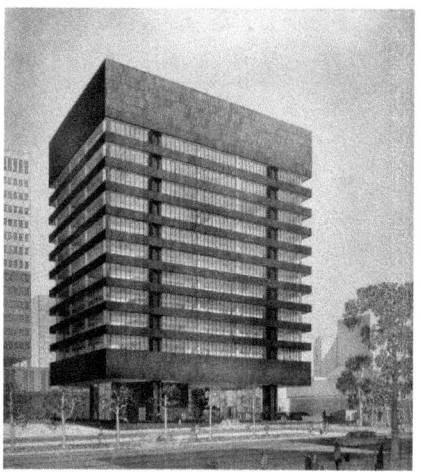

Figure 03: Sun Life (Exhibit #12), Peterson & Brickbauer, Helmut Jacoby, Renderer

In this picture, foliage is present but sparse, but the urban character of Charles Street appears even sparser. The same is true for Jacoby's rendering of the **Mercantile Bank & Trust Building** [04], in which the primary subject is shunted off to the right to emphasize the Federal Plaza's own spatial character. Jacoby's vision of Baltimore was entirely accurate, in an optical sense, and even today what remains conforms closely to what is shown in the rendering.[1] Neither is this vision distant from what one has sensed ever since its inauguration: life at the heart of Charles Center feels frozen in tableau [05]. In fact, the architect Helge Bofinger has written of the "somewhat alienated, virtual reality" of Jacoby's drawings and also of the "vague and shadowless" figures which populate their streetscapes.[2] In the context of urban renewal, the defects of which are so often blamed on failed implementation, do we have here evidence instead for a failed intention?

[1] This remains true, however, only as long as the Mechanic Theater remains standing; the building is under immanent threat of demolition, and Charles Center's original skywalks are already being removed.

[2] Helge Bofinger, *Helmut Jacoby – Master of Architectural Drawing* (Frankfurt am Main: Deutsches Architekture Museum, 2001), 11-13.

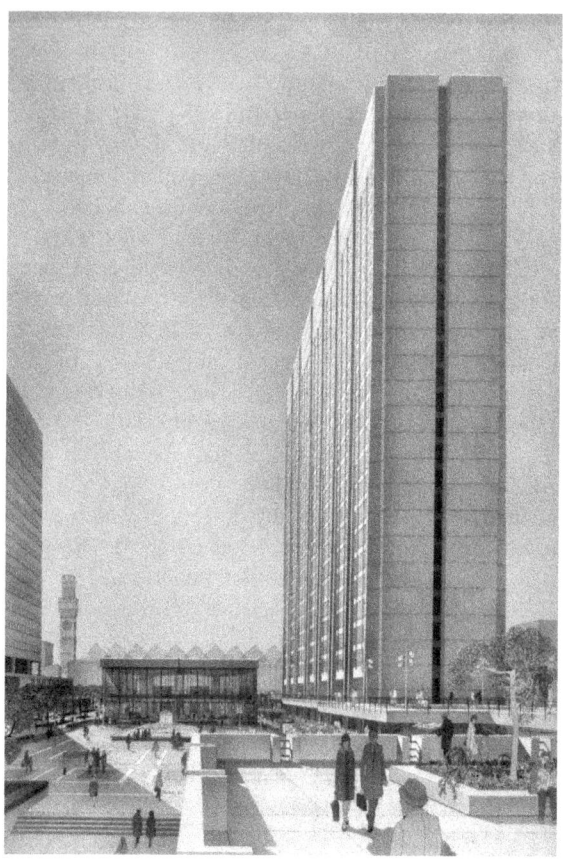

Figure 04: Mercantile Bank & Trust (Exhibit #11), Peterson & Brickbauer, Helmut Jacoby, Renderer

Figure 05: Detail: Mercantile Bank & Trust (Exhibit #11), Peterson & Brickbauer, Helmut Jacoby, Renderer

Perhaps we do. But we have evidence too that intentions may be judged in different ways. An engraving titled "Changing Face of Baltimore," by the painter Dano Jackley, provides an alternative view of Charles Center's redevelopment. Almost exactly contemporary with Jacoby's drawings, this engraving nonetheless appears to be from a different era. The view westward up Lexington Street, from just beyond the intersection with St. Paul Street, shows Mies van der Rohe's **One Charles Center** building as a brooding presence on Baltimore's skyline [06]. In contrast, the high-rises of Baltimore's halcyon 1920s appear more outgoing, even if Jackley's treatment of their facades is hardly less conventional than his rote depiction of the weather. Nevertheless, for that world, unlike our own half a century later, new and old could coexist without pedantry or ideology.

The Baltimore Modernism Project: 01

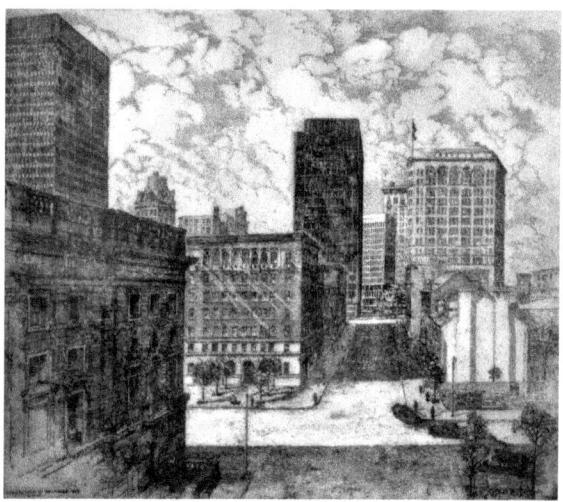

Figure 06: The Changing Face of Baltimore (Exhibit #14), Dano Jackley, Renderer

In retrospect, however, Baltimore's Modernism seems to have found its most congenial expression in the *un*-Heroic.

Many pictures in *The Baltimore Modernism Project* should be familiar. The rendering of **Northwest High School** [07], for instance, shows a building which has been a backdrop to traffic in Northwest Baltimore for almost half a century; its presence there remains entirely quotidian. Yet here, rendered by the crisp lines of a Rapidograph pen, the building embodies its architects' vision for a kind of "suburban renewal." Here was a way forward for Baltimore's white

middle class, much of which nevertheless decamped soon after to other locations beyond the nearby county line. This image reveals to us, therefore, a counter-factual "history" of our city, blithe in its assumptions, yet excruciatingly precise in its depiction of an alternate reality.

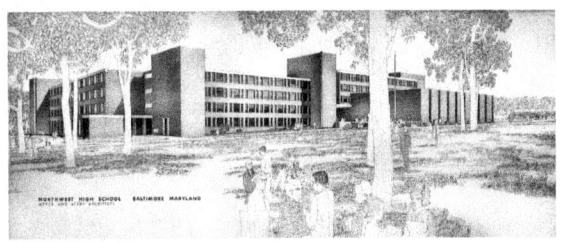

Figure 07: Northwest High School (Exhibit #10), Meyer & Ayers, Architects, Helmut Jacoby, Renderer

Other pictures are practically anonymous. Additions to local hospitals and new facilities were only part of the increasingly technical infrastructure of formerly rural areas outside Baltimore's city limits. Other pictures show how "infill" designs for local street corners could defer to larger, traditionally-styled buildings nearby [08]. Buildings like these are wonderfully urbane and a pleasure for both designers and the city's public alike, then as well as now. But their lessons remain unassimilated, buried beneath the cant of Baltimore's debased public discourse about architecture: "traditional" versus "contemporary" or, worse, "decay" versus "development."

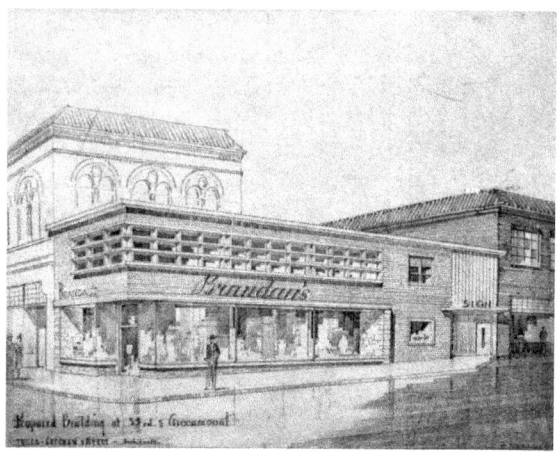

Figure 08: Proposed Building at 33rd & Greenmount (Exhibit #02), Unknown Architect, Unknown Renderer

To elevate that discourse is the urgent message of *The Baltimore Modernism Project*. These artifacts of paper, graphite, ink, and airbrushed pigment attest to the values of their architects and architectural illustrators, of course, and reflect the aspirations of a different time. But their "virtual" world was the direct precursor of our own, and as such they demand renewed attention from us all.

Jeremy Kargon, Architect
Morgan State University, 2012

The Baltimore Modernism Project: 01

Charm Vs. Character

After growing up in Baltimore, I left in 1967. I returned to live here 43 years later. In the meantime, I had visited regularly to see friends and particularly my mother who was also the Mater Familias to a cadre of Baltimoreans who seemed to care deeply about the public image of their city. A professor of art history, specializing in architecture, she was also an active member of city design review boards. She was asked to run for mayor and politely refused. Most effectively she was an art and architecture critic for the Sun Papers during the 1970s, a moment in the city's relatively long history when its prosperity and population dwindled drastically.

It was a hard time. In that period she often locked horns with William Donald Schaefer, especially when "Hizzoner" proposed removing the dome from City Hall rather than restoring it. Such bizarre activity must seem preposterous now but then, with the city looking at bankruptcy and the zeitgeist for urban renewal encouraging the destruction or mutilation of historic buildings and neighborhoods, it was entirely possible at least to consider such action. Schaefer, the ambitious mayor of a city in severe decline that was referred to regularly as "The Armpit of the East Coast," gave the decaying 19th-century industrial town the ridiculous name "Charm City," a name that has persisted given the well-documented sarcastic humor of our citizens. (See John Waters, H.L.

Mencken, Frank Zappa, David Byrne, Charles Bukowski, Gertrude Stein and an endless array of lesser, but equally mordant, notables to be found in the taverns and on the street corners of our crusty metropolis) "Charm City" has caused eyes to roll for 40 years and has framed a slow, painful recovery – or, more interestingly, a reinvention of the city as an alternative to both suburban and "healthy" (read wealthy and socially segregated) urban paradigms. As my mother said in reaction to Schaefer's sardonic hyperbole, "Baltimore doesn't really have charm, but it does have character."

Character – indeed, a commodity much more precious than charm – implies resilience and exceptional idiosyncrasy. It is a high point of that Baltimore character that is rendered in this show: a grand moment of Modernist reassessment of the metropolis when the exceptional nature of this particular city found a comfortable bond with global aesthetic/technical innovations. In those years, Baltimore invited the very best international architects, including Mies van der Rohe (potentially the 20th century's most important and designer of two of Baltimore's greatest buildings, one of which is featured in this exhibit), Walter Gropius, Frank Lloyd Wright, Marcel Breuer, Louis Kahn, Pietro Belluschi, and John Johansen (whose striking urban landmark, the Mechanic Theater, is about to be demolished – another profit-minded example of shortsighted ambitions). These masters were joined by gifted local

The Baltimore Modernism Project: 01

architects whose work constitutes the majority of modern buildings depicted here. This generation joined the finest of many others – Benjamin Henry Latrobe, Richard Upjohn, Maximilian Godefroy, Robert Mills, Ralph Adams Cram, McKim, Mead and White, Daniel Burnham, and John Russell Pope, to name a few – who gave the city its particular magnificence. This was augmented by the good sense, lacking in many other older American cities, to not tear down the rich historic fabric that constituted one of the nation's finest collages of housing, primary elements, and monuments.

It is the work of local practitioners in the period around and after World War II that is most prevalent in this show. While these projects range from simple shops to the city's grandest towers, there is a consistency and rigor in their design and materials expressed further by the renderer's skill. Modernism came late to America. While certain hints of a new aesthetic order were presented as early as 1913 and the Armory Show of contemporary art in New York, it wasn't until the early 1930s that the style gained any traction. Then the efforts of the Museum of Modern Art propelled a slow adaptation of taste toward the forms of Machine Art that would come to dominate aesthetics during the period covered by this show. Good taste was marketed. Sounding more like Target or IKEA, the MoMA launched a series of shows in the '40s entitled "Useful Objects under Ten

Dollars." The public consumed with simple elegance. Architecture was didactic in this regard.

The earliest renderings in this exhibit are of small to medium scale civic buildings, schools, clinics, hospitals, and even stores. They share industrial patina, minimal detail and tactile surfaces. In the case of Baltimore, the local standard was brick, while the international presented itself in exposed concrete. An extraordinarily clear and compelling simplicity combined with forms that derive from Elementarist composition shaped this work. If it had a political charge in Europe, overt ideology was intentionally gone by the time MoMA imported it. While the work seen here could as easily have been found along the streets of Milan a decade earlier, it was not the International Style proclaimed by the MoMA in 1932 in either place. While it represented Fascism in Italy, it represented nothing more than progress and, ,possibly, corporate/municipal power in the U.S. The Modern was becoming universal, not because of mandates from aesthetic pundits but because it was convincingly in tune with new living standards and because it implied lucidity, both formal and cultural. The renderings, despite certain "humanistic" touches designed to convince clients or agencies, speak vividly of quality, material, rational composition, and, as well, timeless coherent space.

The Baltimore Modernism Project: 01

The more recent contributions to the show, mostly renderings of towers or large buildings from the '60s, stray from the modest arguments made by the earlier drawings. They show consummate and sometimes flashy structures. They are certainly minimalist but somehow Baroque at the same time, reveling in shine, mass and reflection. These drawings show spectacular urban sculptures. But buildings, despite a concerted and continuing attempt to be only that, can never not also be complex containers of activity and atmosphere, nor can they not convey the power of state or economy if they are at such a scale. With their dramatic play of light and mass, these renderings stress all these qualities. They advertise strong tactile form convincingly and with confidence. They are heroic and promise vital urban events. They represent a promise for a grand Baltimore.

My intermittent passages back to Baltimore began just before the last of these buildings was drawn. Returning periodically, at least once a year and often attending review board meetings as my own interest in architecture developed while I was here, I could gauge the effects of the evisceration that the city was undergoing during those decades after 1970. But there was also growing an almost grass-roots small-scale redefinition that was beginning to make Baltimore "charming" in fact, along with endowing it with even more "character" to accompany the excesses of that quality that were already there. Loyalty and even satisfaction characterized the

embattled population who had not decided to flee to the beige urban edges but rather to retool the city's sudden emptiness and potential. I also was able to follow the struggles, mostly failures but a few successes, of that aforementioned faction of concerned citizens who were working to keep the urban value that Baltimore already had and to ensure that future development would both respect and augment that value. This was a task of Sisyphus for sure. With the depleted revenue, the federal neglect that was beginning to impoverish all U.S. cities and the greed of both real estate interests and municipal officials, the quality of conspicuous construction in the downtown and of more modest civic buildings and residential complexes throughout the city may have lined pockets in the short run, but was a disaster in the long. A loss of nerve was evident.

Whereas the design eminence documented in this show of work before 1970 added to the collage of styles and periods that Baltimore is an exceptional example of, in the next decade the rush to build anything and to enrich privately and publicly led to work that was simply weak. Architects who built exclusively outside the beltway in Washington were doing iconic buildings near the Inner Harbor. With sculptural constructions of dubious worth replacing the warehouses that had bordered the water, the Harbor itself was a precedent for urban triage. It isolated the not very festive festival marketplace from the anemic rest of the inner city. With the exception

of I.M. Pei's World Trade Center, the Inner Harbor was a Fort Apache populated by pyrotechnic space ships turning their backs to the blight behind them, squatting around a suburban mall meant to attract a suburban clientele, a format repeated by the Rouse Company wherever an available waterfront presented itself; Miami, New Orleans, New York, etc.

Furthermore there was an emphasis on private automobile-centered infrastructure, on garages and widened avenues, at the expense of pedestrians who were discouraged from walking anyway by tendentious reports of crime and mayhem on the streets. This restructuring promoted the interests of car and oil industries, and thus of the era's greatest consumerist gambits, at the expense of plans for civic space activity personified in the Modernist showplace at Charles Center but also by the many smaller plazas and walks that the city had instituted in the previous decades. In that era, Baltimore seemed to want to abolish itself or at least its center.

While visiting I saw opportunity squandered in every new lost chance presented by the development of the city. Simply put, Baltimore lost its architectural/urban mojo during that tough period following the diffident splendor displayed in this show. Speculation and the fast buck dominated developer-driven design in an era in which the municipality was willing to say yes to almost any initiative for the sake of revenue. The deterioration of the downtown, especially the bustling business axis

The Baltimore Modernism Project: 01

that had been Howard Street, at the expense of the commercial gated community that was forming around the Inner Harbor, combined with the disorientation of architectural culture itself. There were exceptions, but Post-Modernism also helped in weakening the will toward the recovery of fading quality. While Post-Modernism revolutionized many other intellectual and visual disciplines, in architecture it seemed to visually imply the debased and exaggerated mimicking of historical styles. It reeked of disrespect and thus lent itself especially to the accelerated appetites of developers. Its highpoint was short lived but the larger firms in Baltimore, given the city's self-deprecating devotion to Grade B design, continued to produce sad pastiches of exaggerated historicist forms for decades after. It is not surprising that this is still the case given the dominance of arbitrage-style speculation among developers during a period in which they have been ascendant. Frankenstein's monster came to rest on many corners in the enervated metropolis where urban value was the last concern.

This exhibit thus should remind us that, once, there was a shared notion that Baltimore could both embrace a glorious history beginning in the 18th century, but prolific in the 19th, and also juxtapose to that history and its artifacts many new manifestations of the notion that a city is about culture, that it both articulates and is articulated by society, by wealth but also by the collective. That the primary representation

of inevitable radical cultural change is urban seems to be a given. That monumentality lies in the city as a work of art as much as in specific structures is likewise assumed. That future, present, and past meld in civic space; that Modernism has remained a rich salute to all three; that this city is changing and adapting, in an exciting way, to the alternative lifestyles that can find a rough comfort here in the new Pastoral that coexists with suffering and poverty within its borders; that this change should also alter the expression that it finds in architecture; and that the fine drawings in this exhibition both stand on their own aesthetically and exemplify all the above conditions: these are the point here. Smaller Baltimore firms have begun to revive many of the concerns and protocols that produced the consistent value evident in these drawings. Beginning with small projects, their work is now becoming the new standard for larger civic and institutional buildings.

By what is represented in the drawings but also by the fact that they were done by hand, this show should further remind us that the compromises and accommodations to the corporate initiatives that have both supported and done damage to the image of the city should be viewed critically and countered when necessary. For now the slick computer drawings and the much less skillful constructions they portray are set aside and again we view the aspiration and quality represented by these Modernist renderings that serve

to remind us of what this city was, what it isn't, and what it can be.

Michael Stanton
Hampden Heights, 2012

Revisionist idiom

City architecture is another matter. The design of the Mercantile Bank and Trust Company posed different questions for its architects and elicited from them a different but equally distinguished response. They worked in the new, revisionist modern idiom which has developed for monumental public buildings.

Charles Center, in which the bank would form one of the final elements, was a given. The Mechanic Theater, a positive statement in the manner of the late buildings of Le Corbusier, also had to be lived with and the assertive and ugly Federal Building loomed alarmingly to the south.

The Peterson and Brickbauer design of the bank is successful because it took these existing buildings and the space of Hopkins Plaza into account, reaching an accommodation by subtle stylistic nuances, manipulation of materials and forms and the introduction of a feeling of luxury in the materials and textures of the exterior and in the entrance and lobby of the building.

The concrete of the theater is rough; if the shapes that compose the building were not an orderly expression of the interior space they would be violent. The bank is tall and slender, discrete, its concrete surface is roughened but it appears like fabric stretched over a frame. The windows are ample and well

proportioned, a contrast that challenges the Federal Building. The bank and its small satellite building succeed in dominating the square without overwhelming the design of the theater.

This design is a subtle exercise in revised modern. Its cleanly lines are an inheritance from the early style. Its concrete surfaces belong to the new revisionism and are kin to the textures of the theater. The richness of its lobby is purely for pleasure and one is grateful for it.

To mention what is missing from these awards is to look a gift horse in the mouth, and complaint must be prefaced by admission that what is missing is not the responsibility of the architectural profession, but of the society it serves. Buildings for suburbs and downtown corporate clients represent but a tiny part of what we need from gifted architects. Housing for the inner city, methods to restore abandoned older houses, ways to join old neighborhoods with new structures, composition of inner city open spaces need a lavish expenditure of talent and public wealth. I would suggest that in the future the chapter establish special awards in these categories to encourage excellence and acknowledge the human need theorists of the early Modern Movement declared it was the architect's purpose to satisfy through design.

The Baltimore Modernism Project: 01

SPECTATOR

Cream of the crop from local architects

Phoebe Stanton
Bolton Hill, 1972

The Baltimore Modernism Project: 01

12 e n ave Screen Sh#6...

18 e n ave Screen Sh#6...

2211 md ave goodwil...

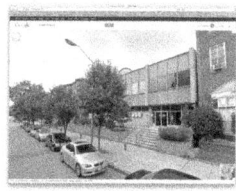
2218 charles wypr Sc#...

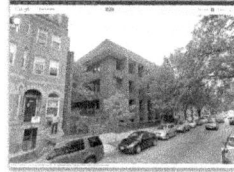
2335 charles Screen #6...

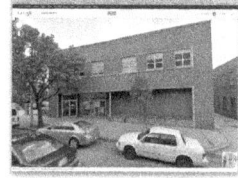
2529 charles Screen #6...

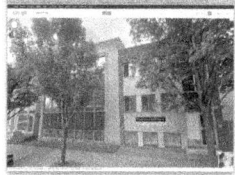
2616 md ave Screen S...

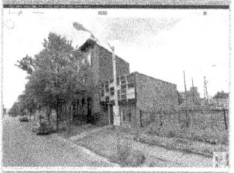
2626 md ave Screen S...

Baltimore Modernism Everyday (excerpt)

The Baltimore Modernism Project: 01

About The Baltimore Modernism Project

The Baltimore Modernism Project is an open ended venue for exploring the past, present and future of Modernism in and around Baltimore.

The present incarnation of The Baltimore Modernism Project, renderings from the archives of the Baltimore Architecture Foundation, was c0-curated by Fred Scharmen, Michael Stanton, and Jeremy Kargon, with assistance from Tracey Clark, Marian Glebes, and Gabriel Kroiz.

About D center Baltimore

Dcenter Baltimore is a catalyst for design thinking and making in the Baltimore region. It is a big tent under which various disciplines and communities can come together. This organization aims to promote increased awareness and expectations for quality design in the region, and to support the production of new work. Dcenter is generously supported by the National Endowment for the Arts and the Robert W. Deutsch Foundation.

The Baltimore Modernism Project: 01

About The Baltimore Architecture Foundation Archives

The BAF has been acting as conduit for over 20 years for architects and architectural firms requesting a safe and useful repository of their work, especially drawings and renderings.

For more information, email dcenterbaltimore@gmail.com, or see dcenterbaltimore.com

The Baltimore Modernism Project: 01

Appendix: Selected Photographs
by Jeremy Kargon

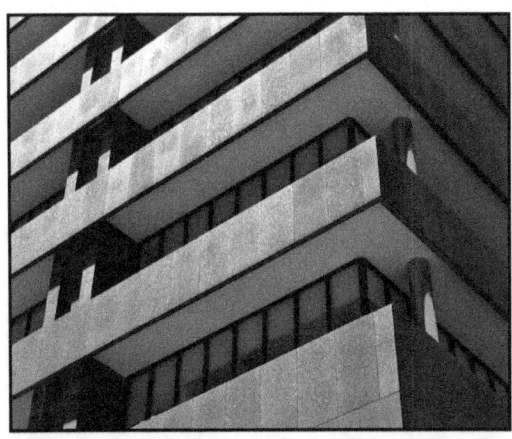

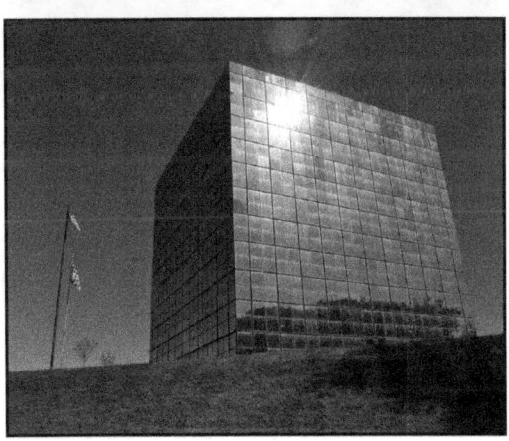

The Baltimore Modernism Project: 01

Appendix: Selected Photographs
by Jeremy Kargon

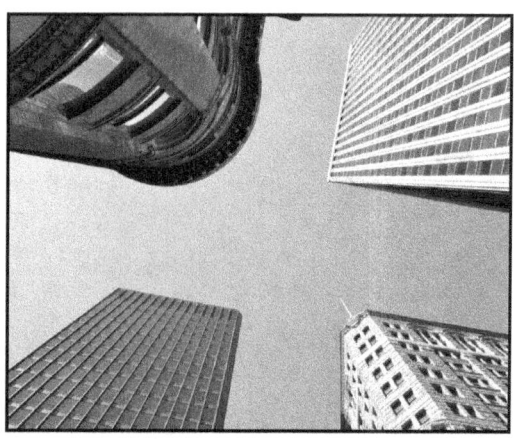

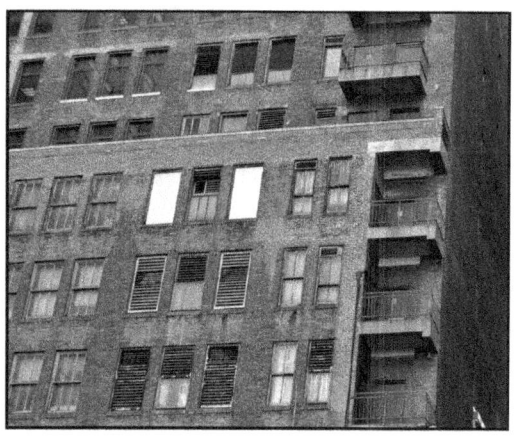

The Baltimore Modernism Project: 01

Appendix: Selected Photographs
by Jeremy Kargon

The Baltimore Modernism Project: 01

Appendix: Selected Photographs
by Jeremy Kargon

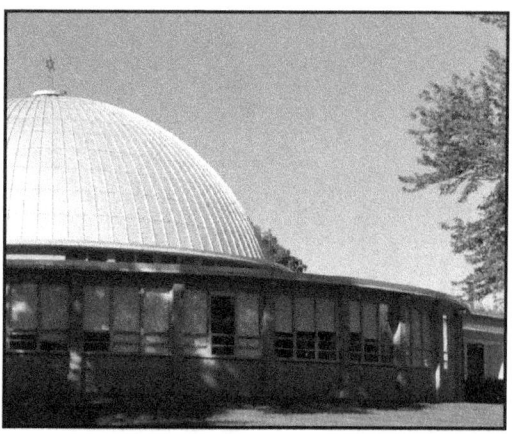

The Baltimore Modernism Project: 01

Appendix: Selected Photographs
by Jeremy Kargon

The Baltimore Modernism Project: 01

Appendix: Selected Photographs
by Jeremy Kargon

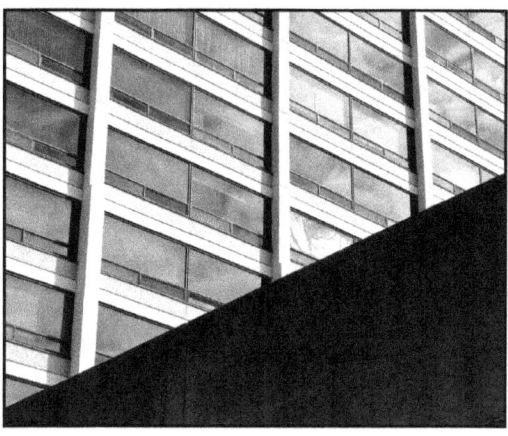

The Baltimore Modernism Project: 01

Appendix: Selected Photographs by Jeremy Kargon

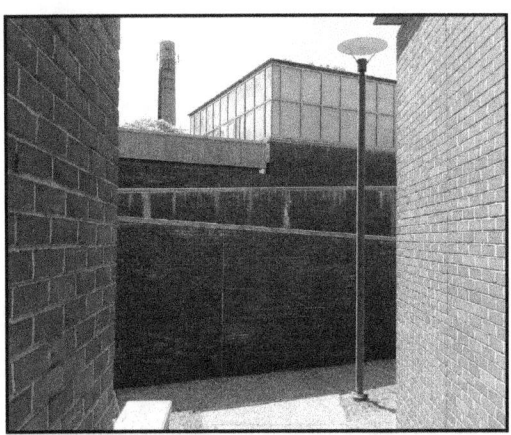

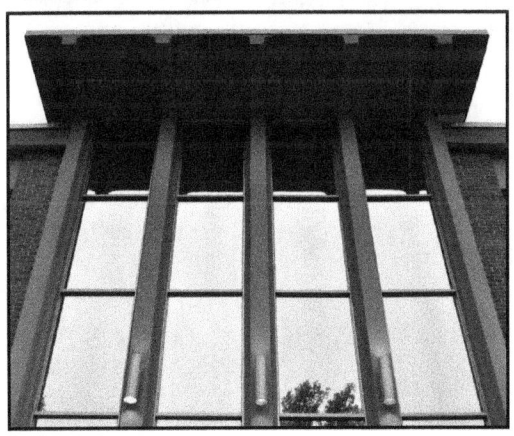

The Baltimore Modernism Project: 01